TUOLUMNE
IN PICTURES

RYAN ALONZO

YOSEMITE CONSERVANCY
Yosemite National Park

For Margaret —RA & ES

Botanical nomenclature sourced using the Jepson
Flora Project (2nd edition), 2012. *Jepson eFlora*,
http://ucjeps.berkeley.edu/IJM.html, accessed on
October 30 and November 1, 2014.

Design by Nancy Austin

ISBN 978-1-930238-57-2

Printed in China by Everbest Printing Co. through
Four Colour Imports Ltd., Louisville, Kentucky

1 2 3 4 5 6 – 19 18 17 16 15

YOSEMITE
CONSERVANCY.

yosemiteconservancy.org

Front cover photograph: The Tuolumne River glides through the meadow
in its granite bed. Lembert Dome catches the last sun of the day.

Previous page: Under a bright sweep of cloud, the granite domes and
peaks above Tuolumne Meadows let go of the last light of day.

INTRODUCTION

...olumne Meadows sits at the edge of ...e world. Above, Sierra peaks jut into ...e sky. To the east, Tioga Pass divides ...e drainage to the Pacific from the ...eat Basin. Tuolumne rests as the last ...tpost of the human world in Yosemite ...tional Park, bordering a vibrant ...ountain wilderness.

The flow of glaciers sculpted the ...mes and mountains that frame ...s majestic landscape, depositing ...anite soils that give Tuolumne life. At ...500 feet (2,621 meters) of elevation, ...olumne Meadows spends much of ...e year under a coat of snow. But for a ...ief time between June and September, ...is terrain becomes a lively flowered ...earing between the waves of granite ...aks. Plants, animals, and people have ...aited all year to enjoy summer in the ...eadow.

Tuolumne's fleeting seasonality ...ites participation in a natural cycle. ...thusiasts become sensitive to change ...the river's flow, the blooms of plants, ...d the arrivals and departures of ...sects, amphibians, birds, and mammals. ...is ecological community, while ...silient to the elements, is vulnerable to ...man impact from the summer crowds ...ho now access the meadow with ease ...om Tioga Road. Visitors show great

care in this landscape, careful to practice leave-no-trace principles. Devotees depart Tuolumne transformed: with senses heightened, appreciation for adventure stirred, and thoughtfulness for living things more acute.

This book is divided by the natural elements that define this place:

meadow, flora, sky, water, and rock. This focus allows Ryan Alonzo's photographs to delve into the essence of each component of Tuolumne. The photographer can often be found miles from any road atop an unnamed dome, waiting for the perfect combination of color and light to drop into his lens.

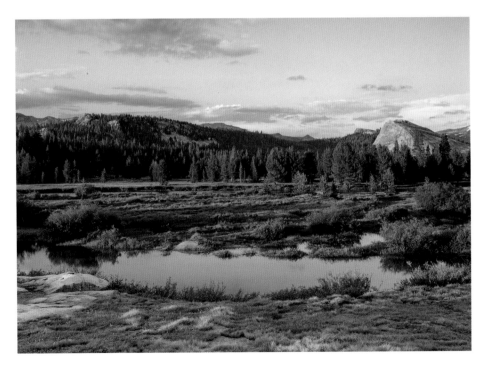

MEADOW

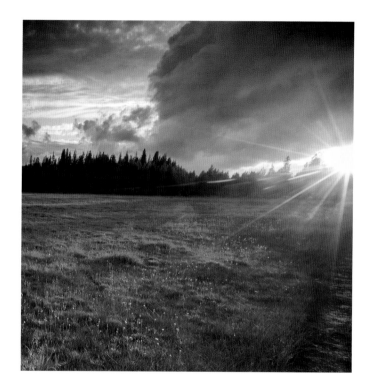

Seated just below the high peaks of the central Sierra Nevada, in the eastern corner of Yosemite National Park, Tuolumne Meadows endures long snowy winters. When the snow melts in the spring, the river rises and meadow inhabitants awake in a flourish of life and color.

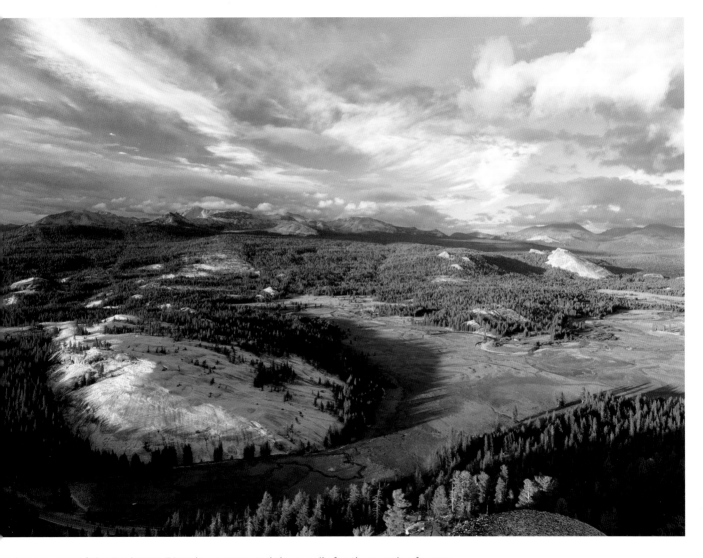

The long curves of the Tuolumne River have saturated these soils for thousands of years, creating the open and rich habitat for sedges, grasses, rushes, and flowers.

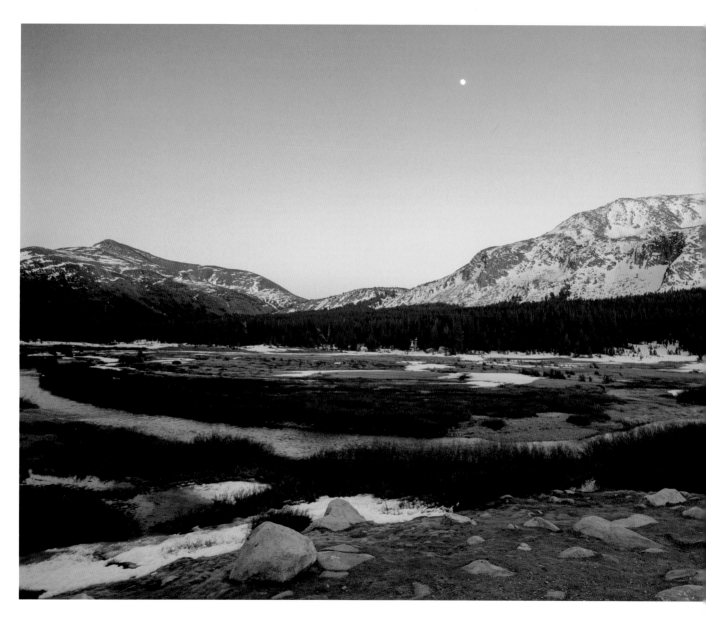

On an early spring evening, the sun's warmth departs before its last flush of color, lingering on snowbanks.

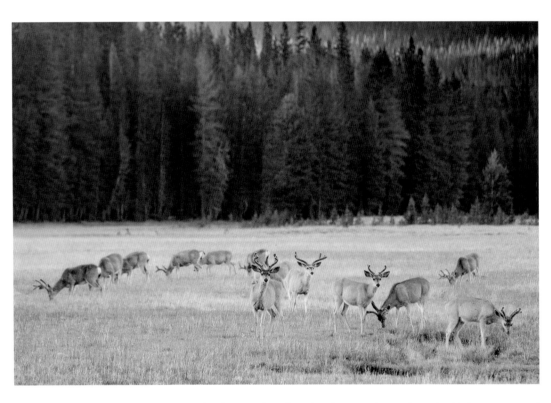

Herds of mule deer (*Odocoileus hemionus*) migrate into the high country and graze the quiet parts of the meadow during the brief window of summer.

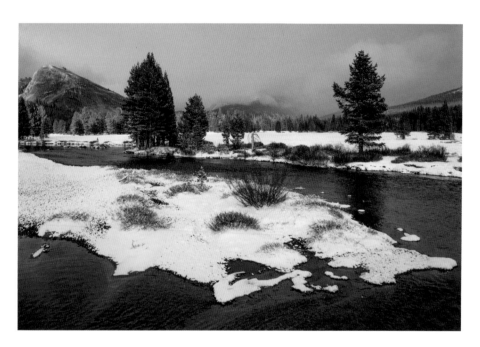

A blanket of silence, snow is both destructive and generative. The water that sustains the high mountain community drips from cold snowbanks throughout the year.

Evidence of enormous glaciations is abundant throughout the high country. Before the glaciers melted, they moved huge boulders many miles, leaving them where they sit today, in the thin soil of the subalpine meadow.

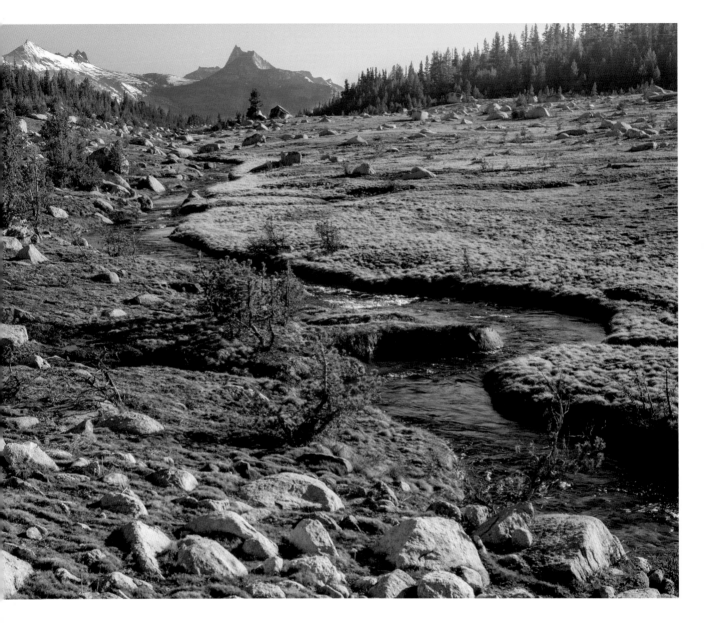

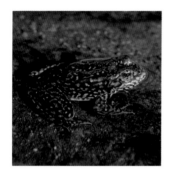

Once the most common vertebrate in Tuolumne Meadows, the beautiful Sierra Nevada yellow-legged frog (*Rana sierrae*) is now so rare it is a federally protected endangered species. They spend three or more years as tadpoles in deep alpine lakes.

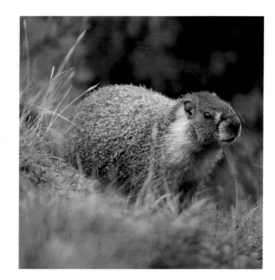

Yellow-bellied marmots (*Marmota flaviventris*) hibernate through the alpine winter. Summer finds them grazing and gazing at the peaks on warm granite rocks, building up fat for next year's long sleep.

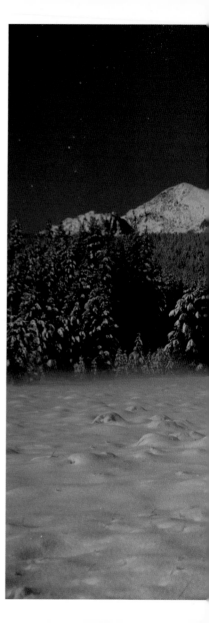

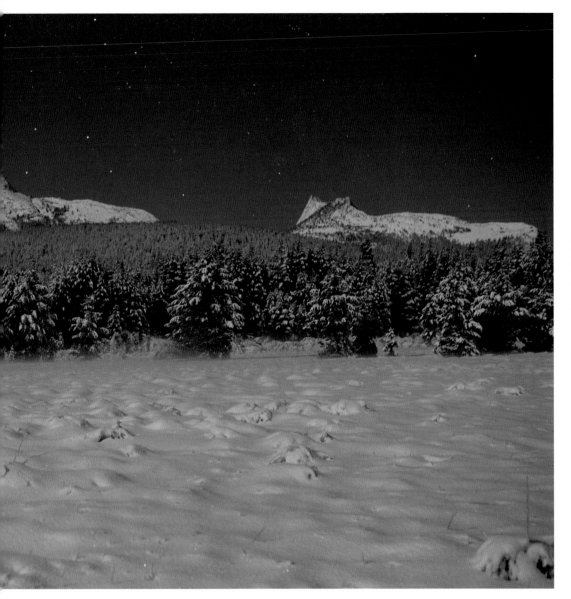

Starlight falls on the hushed meadow. Though it is still summer throughout most of California, the season has already changed at Tuolumne Meadows, under a blanket of September snow.

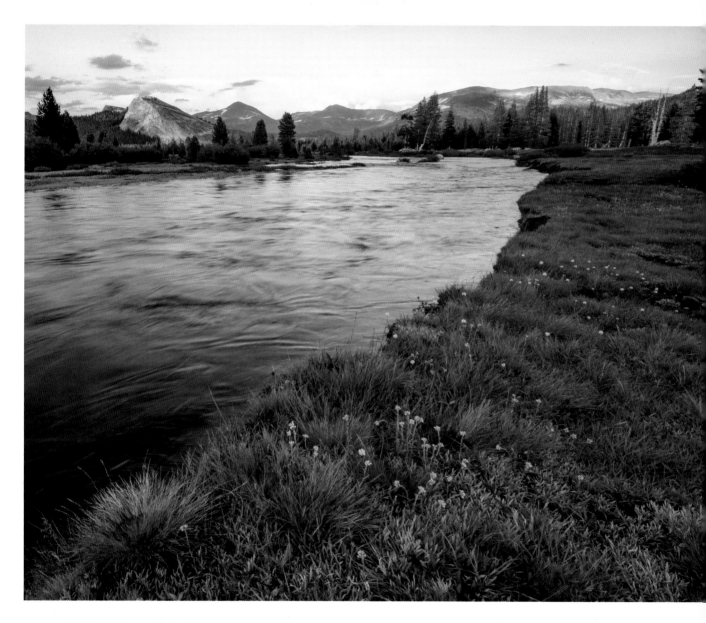

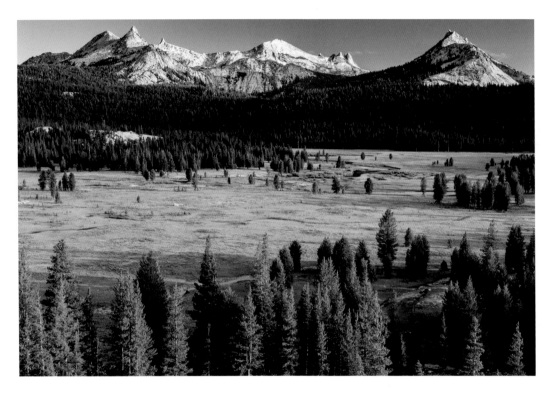

An American Indian summer encampment for thousands of years, this meadow inspired the creation of Yosemite National Park. Tioga Road allows access to this rarefied mountain ecosystem and into the miles of wilderness beyond.

st light stretches across the Tuolumne River
d the bright pussy-toes (*Antennaria rosea*)
at bloom by its side.

FLORA

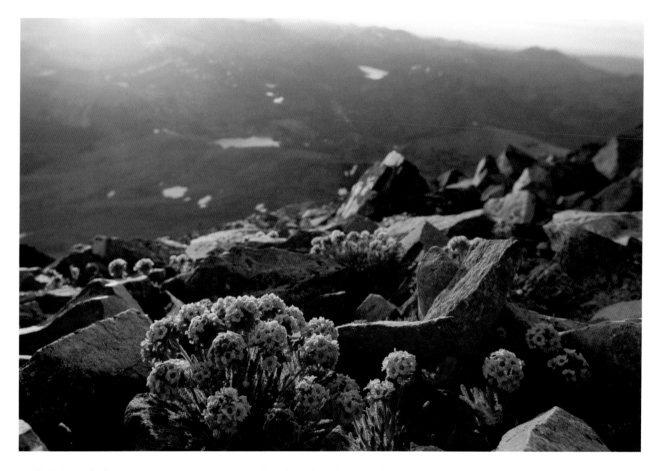

As if deriving its intense color from the sky itself, a sky pilot (*Polemonium eximium*) only blooms at the pinnacle of the highest peaks. It trembles in the evening breeze, releasing its fragrance at the top of the world.

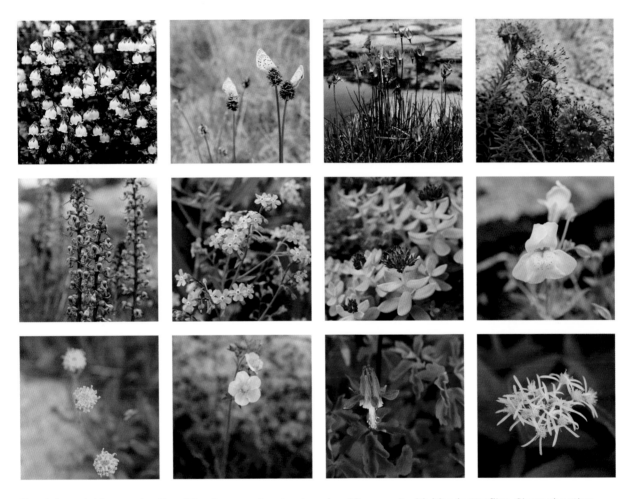

Top, left to right: moss heather (*Cassiope mertensiana*), sedge (*Carex* sp.) with blue butterflies, Sierra shooting star (*Primula subalpina*), mountain heather (*Phyllodoce breweri*). Middle, left to right: elephant's head (*Pedicularis groenlandica*), stickseed (*Hackelia* sp.), western roseroot (*Rhodiola integrifolia* subsp. *integrifolia*), Tiling's monkeyflower (*Mimulus tilingii*). Bottom, left to right: raillardella (*Raillardella* sp.), cinquefoil (*Potentilla* sp.), columbine (*Aquilegia formosa*), arrowleaf ragwort (*Senecio triangularis*).

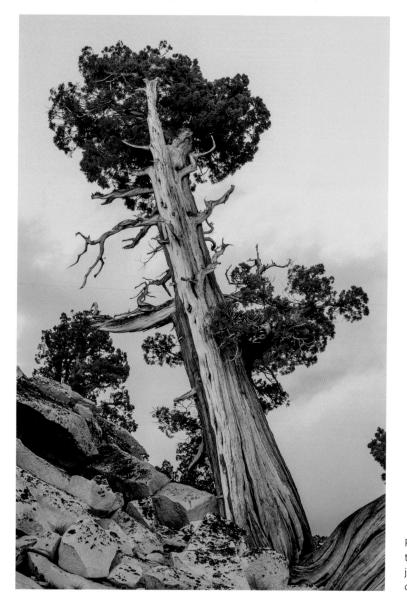

Each meadow, cliff shad
creek, and crack in the re
creates a microclimate, inhabi
by flora perfectly balanced
that particular spot. Clockw
from top left: Lupine (*Lupir*
polyphyllus) prefers this v
meadow. Lodgepole pine (*Pir*
contorta subsp. *murrayar*
dominates the forest. 1
succulent Sierra stonecr
(*Sedum obtusatum*) clings
a tiny crack in a granite sl
Amanita muscaria, commo
known as the fly agaric, a
countless other mushrooms eru
from under the forest duff af
summer rain graces the pea

Resilience paired with elegance:
the bronze, gnarled trunks of western
juniper (*Juniperus occidentalis*)
cling to steep, sunny talus slopes.

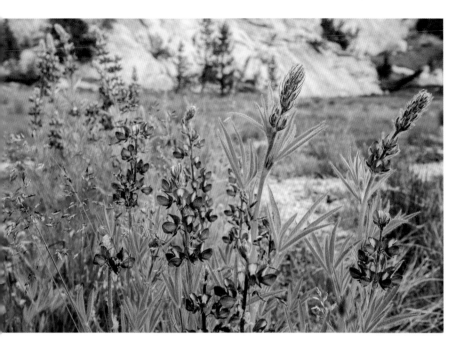

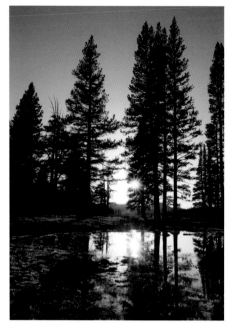

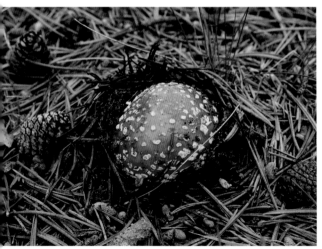

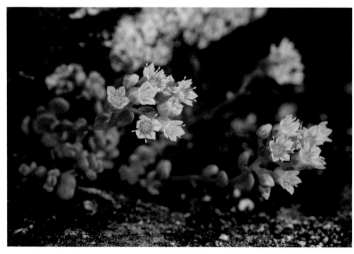

SKY

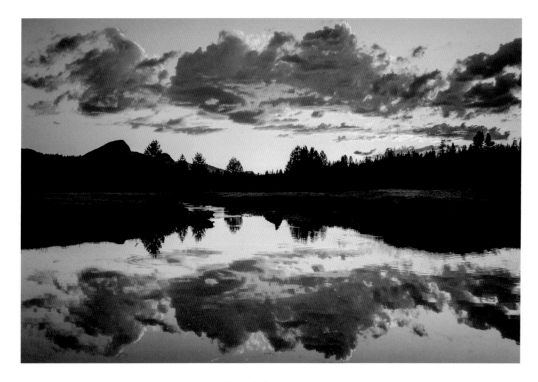

The deep tranquility of a Sierra sunset, though fleeting, makes an impression forever.

The Milky Way rises over Mount Dana.
The dark night sky over Tuolumne
enchants stargazers, inviting
the imagination into the reaches
of space and ancient lore.

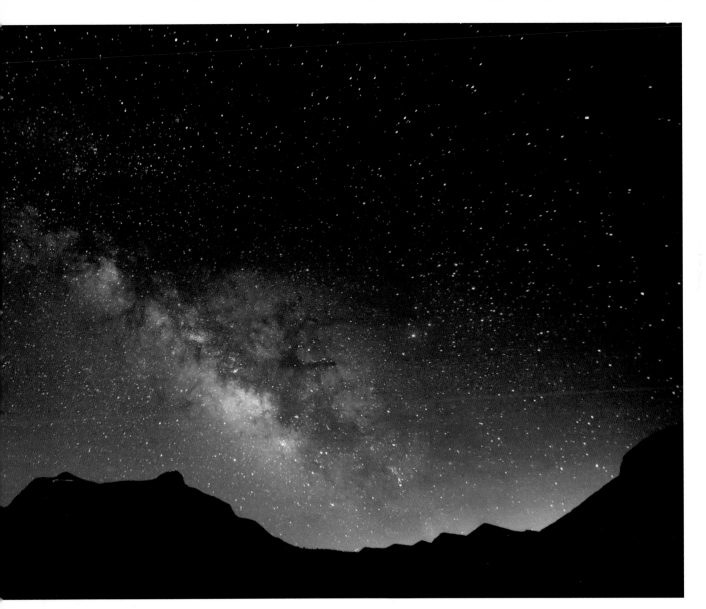

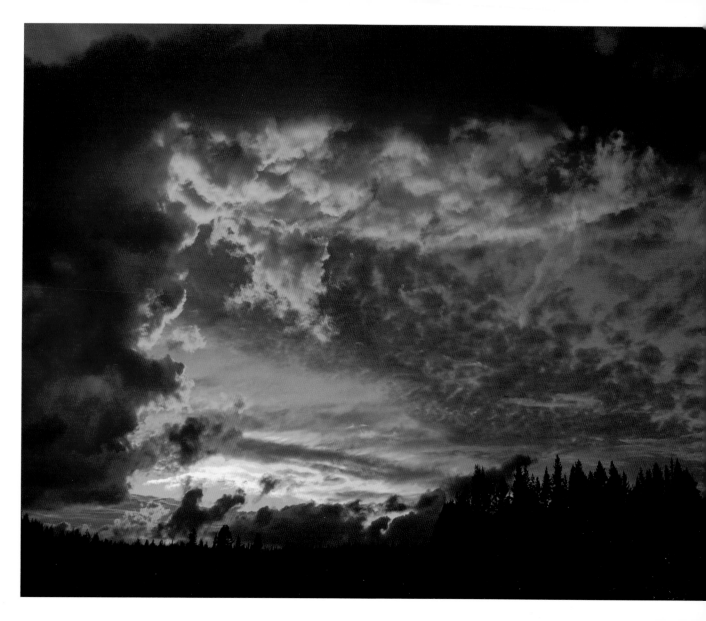

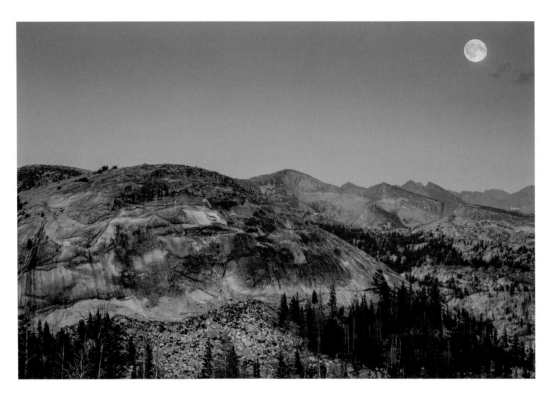

In the absence of clouds, the moon coaxes the rugged landscape to join its stillness.

Clouds are the dramatic players in
the grand theater of the mountain sky.

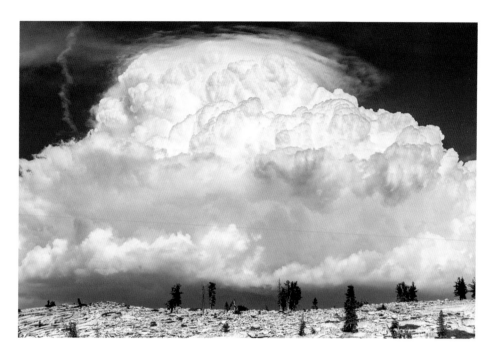

Torn open by high peaks, cumulus clouds dump rain and strike granite with their lightning, sending thunder echoing for miles down glacial canyons.

As the source of Sierra snow, clouds produced the glaciers and rivers of Tuolumne. These always-changing, wispy bodies of water have sculpted Tuolumne's hard granite peaks and sustain its forest and meadow.

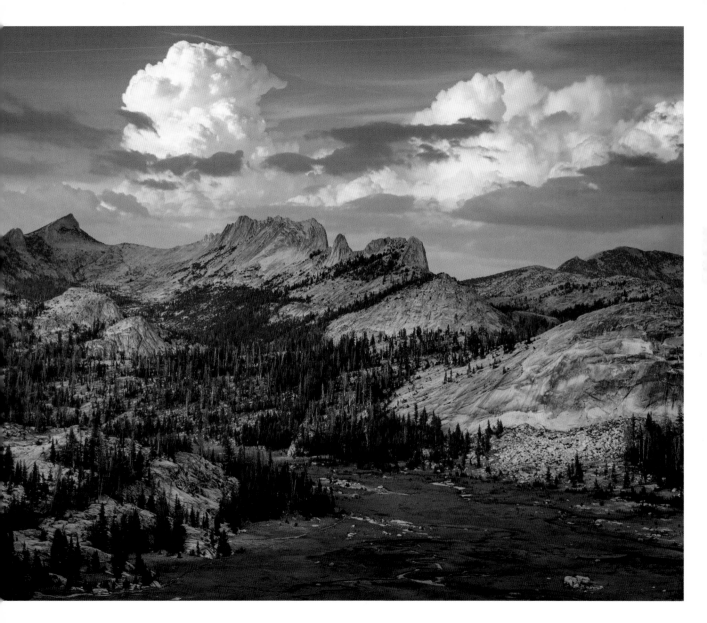

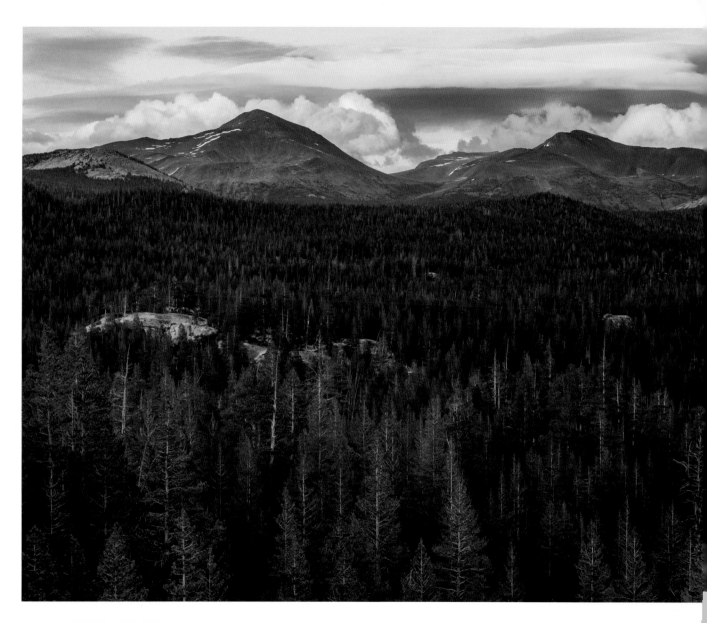

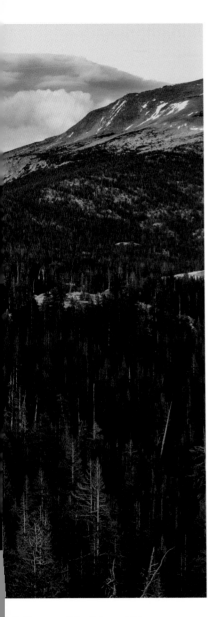

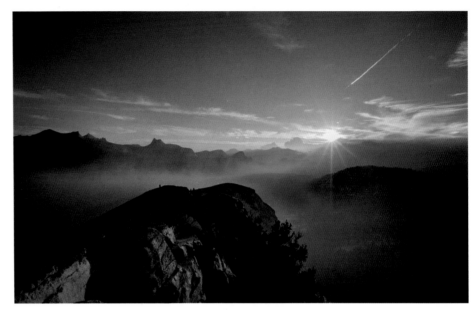

A natural part of California ecosystems, wildfires inflect the summer sky with orange light and strange blue shadows.

Because of its height, the Sierra Nevada collects clouds on its crest. High winds over the range shear lenticular clouds. The ever-moving sky is an effervescent frame, constantly redefining the view of mountains, rivers, lakes, and trees below.

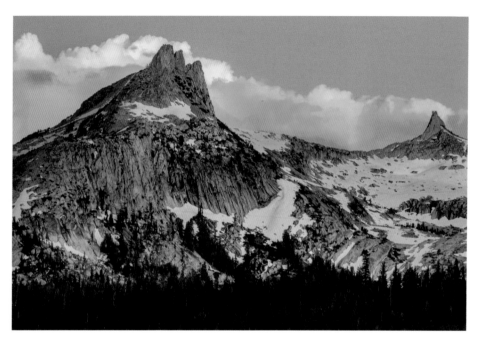

"And how glorious the shining after the short summer showers and after frosty nights when the morning sunbeams are pouring through the crystals on the grass and pine needles, and how ineffably spiritually fine is the morning-flow on the mountain-tops and the alpenglow of evening. Well may the Sierra be named, not the Snowy Range, but the Range of Light." —John Muir, *My First Summer in the Sierra*, 1911

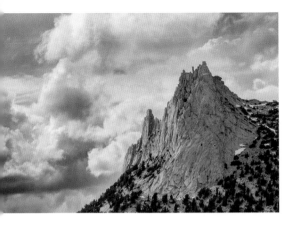

The spectacular granite nunataks of the Cathedral Range (both images) form the southern watershed of Tuolumne Meadows. Cathedral Peak (top) is visible from much of Tuolumne, though its appearance changes dramatically from one spot to the next, depending on light, perspective, and time of day.

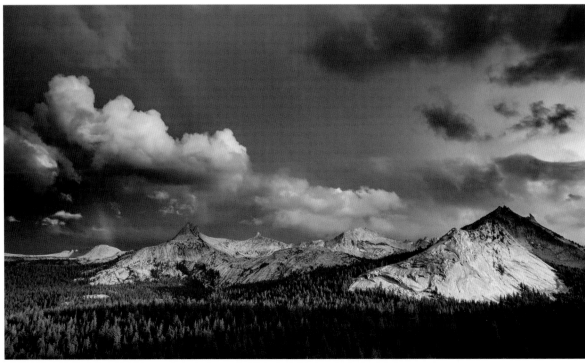

WATER

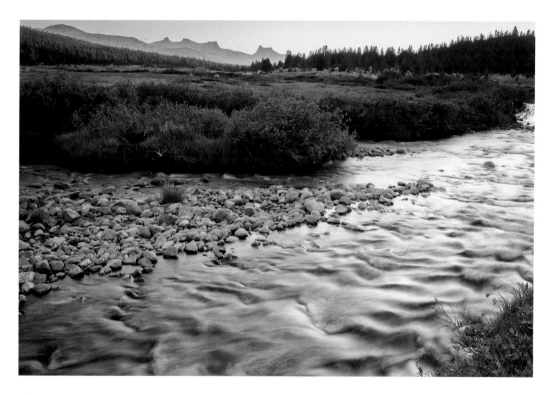

The Tuolumne River is the beating heart of this meadow. Downstream, the river begins to descend, carving the granite bedrock into the elegant, polished Grand Canyon of the Tuolumne.

In late summer and fall, the river drops low, its mood gentle and its voice a soft chiming as tiny-lipped waves fold endlessly.

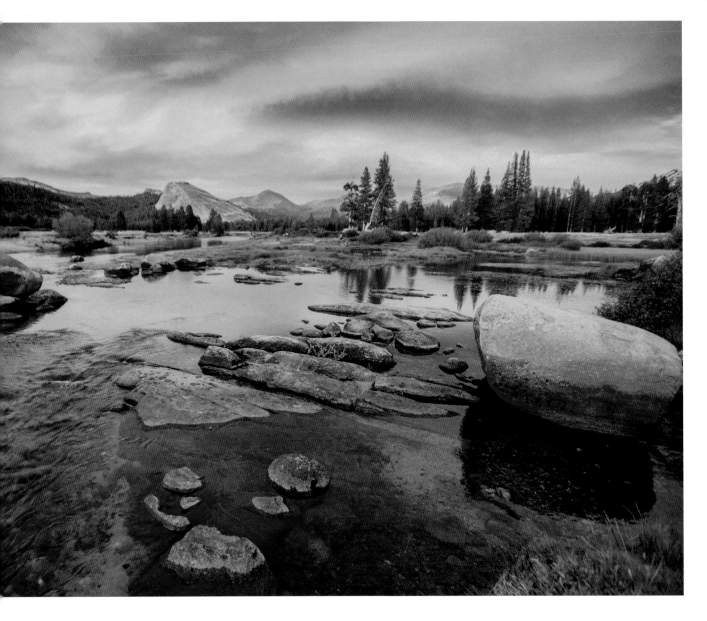

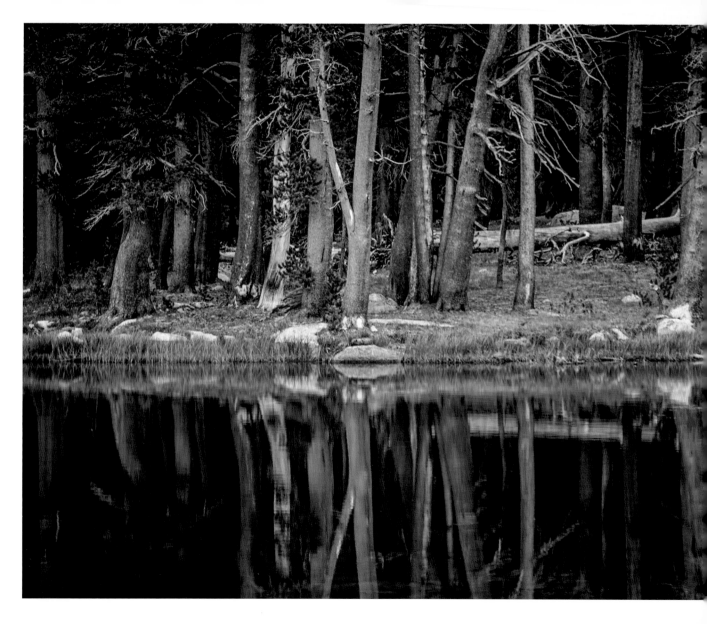

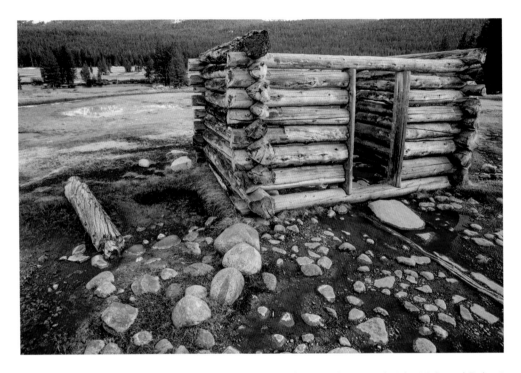

At Soda Springs, carbonated water bubbles up from underground. John Muir and Robert Underwood Johnson camped nearby in 1889. Motivated largely to protect Tuolumne Meadows, the two men worked together to create Yosemite National Park. Their efforts paid off in 1890, with federal protection guaranteed by law under President Benjamin Harrison.

In this wild place, the deep rhythms of nature emerge. Within the rich waterside habitat, growth, reproduction, predation, and decomposition become a symphony of life in the forest.

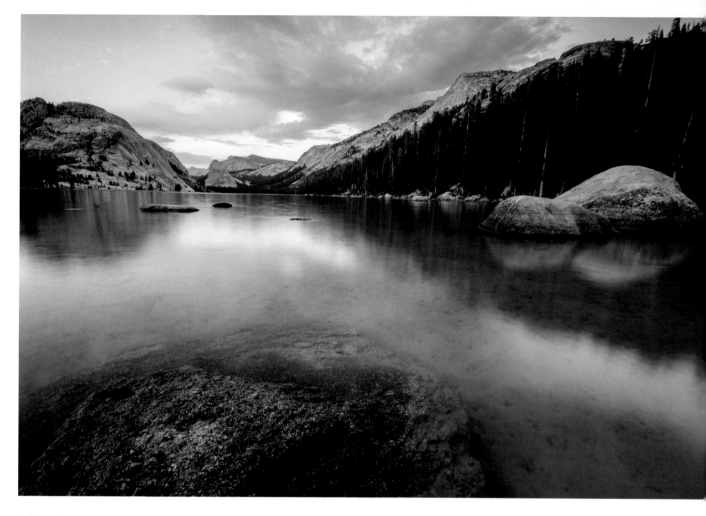

Still as glass among polished granite, Tenaya Lake was called Py-we-ack (lake of the shining rocks) by Chief Tenaya, and the Ahwahneechee who for centuries lived in Yosemite Valley. This glacial lake is 114 feet (35 meters) deep in places, though it dropped considerably during two warm, dry climate shifts almost a thousand years ago, evidenced by tree stumps protruding from deep underwater. Here, for a time, a forest grew.

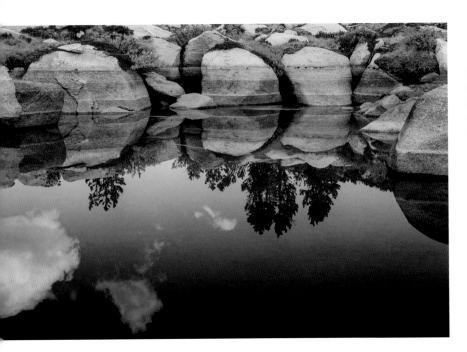

Late-season yellow of willow leaves fringes an alpine pool. Change is evident in the lines on the rocks, marking higher water and the summer bloom of pine pollen.

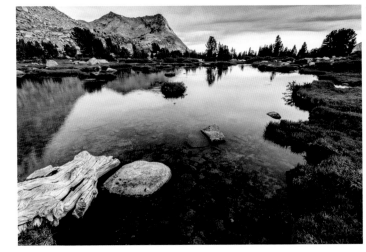

Yosemite National Park is graced with 2,655 lakes and ponds, many scooped by the glaciations that have passed through these mountains. A cirque lake, like this one, reflects the unique beauty of its granite bowl.

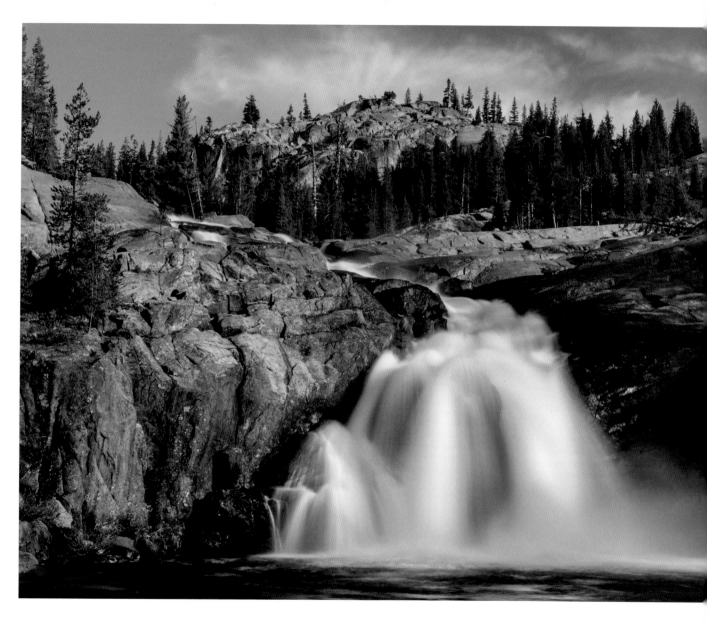

The lodgepole pine forest that surrounds Tuolumne Meadows is reflected in a high-country pool. Shallow bodies of water are important habitat for Yosemite toads (*Anaxyrus canorus*) and Pacific tree frogs or chorus frogs (*Pseudacris regilla*). Deeper alpine lakes that don't freeze solid support the endangered Sierra Nevada yellow-legged frog.

The thunder of Tuolumne Falls reverberates through the rock, making the immense power of water tangible.

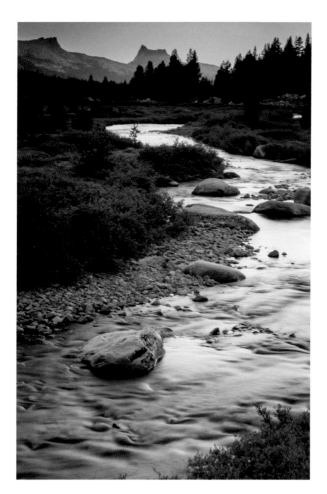
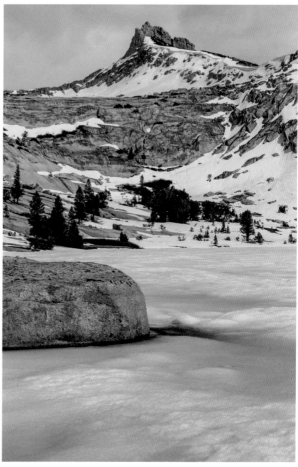

Left: Unicorn (left) and Cathedral (right) Peaks. Right: The Cockscomb. The Tuolumne landscape is entirely shaped and determined by the flow of water, and the water that collects here affects everything downstream. The precipitation captured by the Sierra Nevada provides water to much of the state of California. Snow from these mountains provides an invaluable reserve of fresh water.

Opposite: Fortune smiles on the traveler who happens the moon rising twice, once in the sky and once in the riv

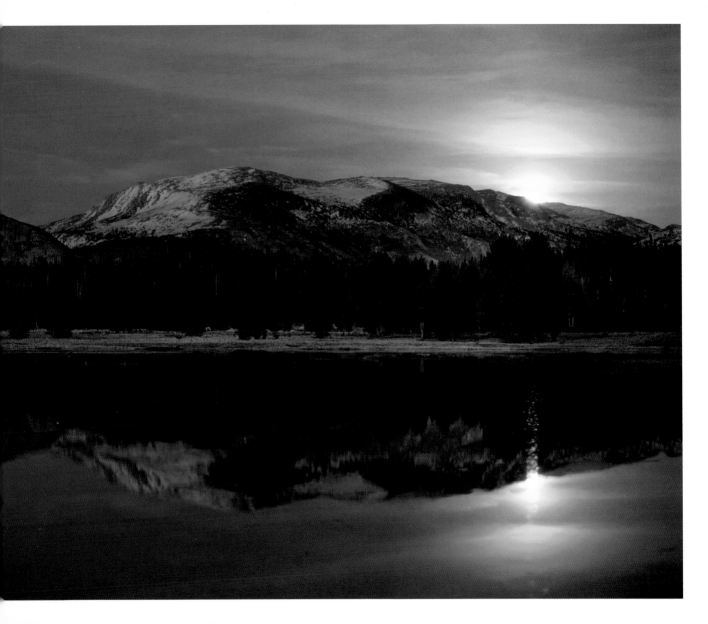

ROCK

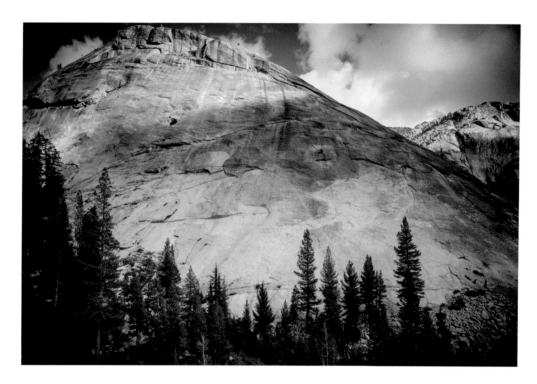

Pywiack Dome. Granite is perhaps Tuolumne's most famous and abundant asset. Polished, rounded into domes, and sharpened into peaks by glaciation and erosion, this drama of stone is beloved by bighorn sheep (*Ovis canadensis*), falcons and eagles, rock climbers, poets, adventurers, photographers, and geologists alike.

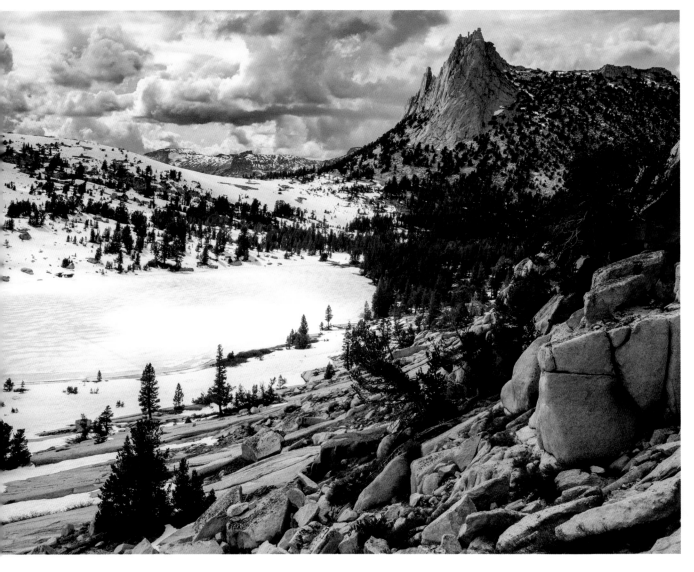

Looking at Cathedral Peak on a snowy afternoon, one can imagine the enormous volumes of ice that once filled these valleys.

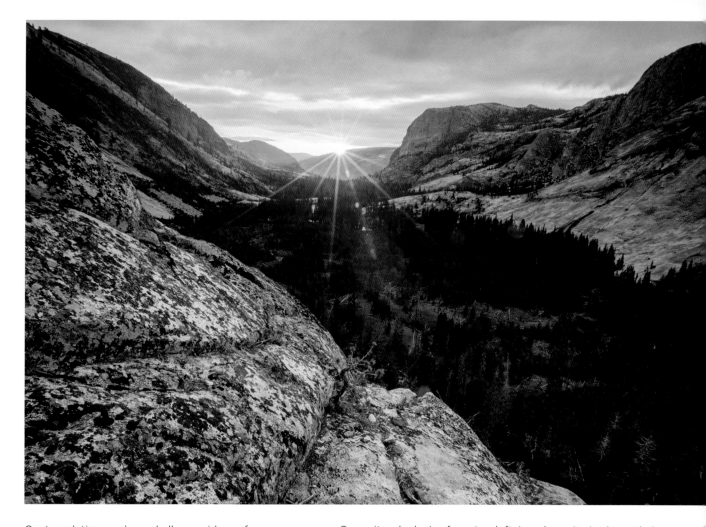

Contemplating geology challenges ideas of permanence and the significance of a human sense of time. Long before massive ice sheets gathered and receded here during several glacial periods, these granite features were magma deep inside volcanoes.

Opposite, clockwise from top left: Local granite is elegantly incorporat in Parsons Memorial Lodge, a national historic landmark, built for the Sierra Club in 1915. The colorful highlights of hearty lichen coloni North America's tiniest member of the rabbit family, the pika (*Ochoto princeps*). Cracks and joints enrich the texture of peppered gran

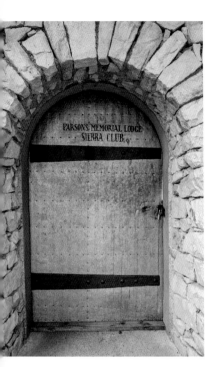

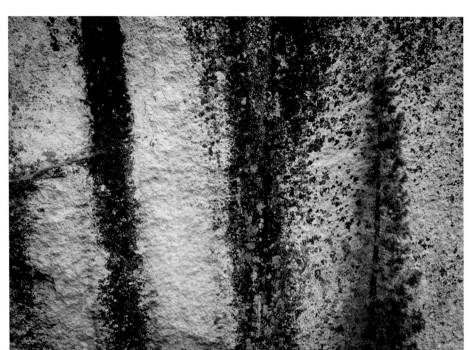

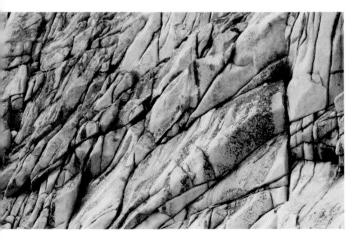

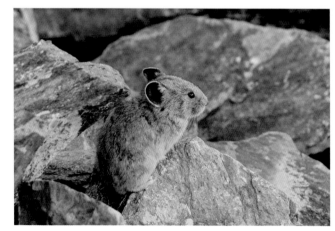

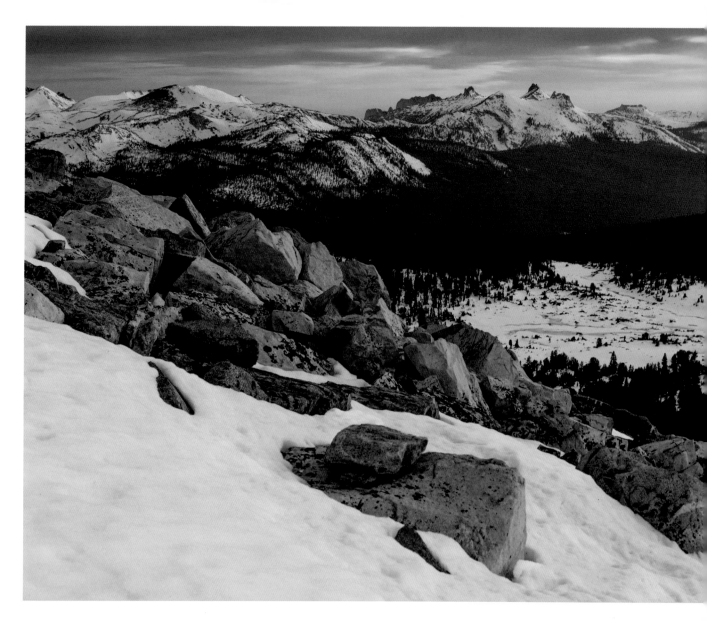

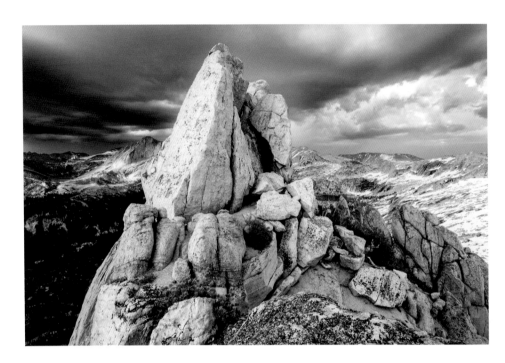

The sky feels almost within reach from these peaks, here soaring almost 11,000 feet (3,350 meters) of elevation.

From high places the rippled and broken spires of the Cathedral Range appear as a choppy sea, rolling at the slow pace of geologic time.

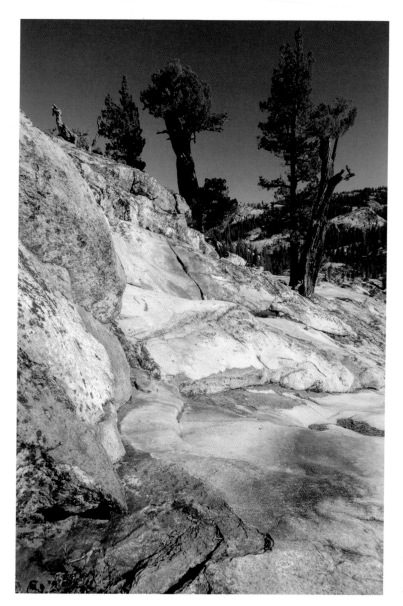

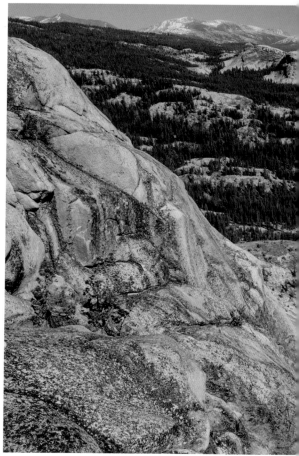

Water stains and their associated lichen colonies pattern the river-polished rock in the Grand Canyon of the Tuolumne.

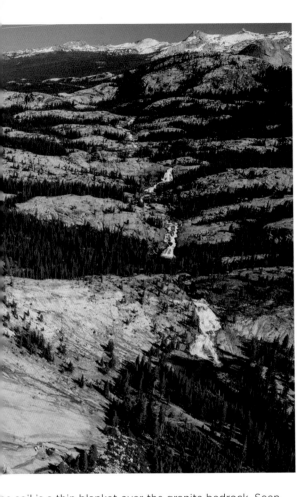

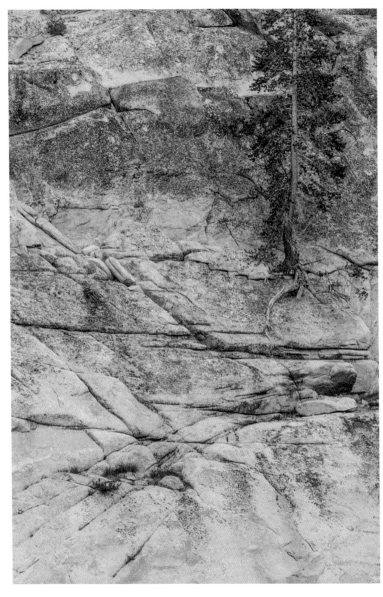

he soil is a thin blanket over the granite bedrock. Seen
om a distance in the Grand Canyon of the Tuolumne, the
usculature of rock dominates the landscape, with creeks
d pockets of vegetation running like veins into the
owerful Tuolumne River.

The texture of minerals juxtapose with the
tenacity of life like a poem on this granite wall.

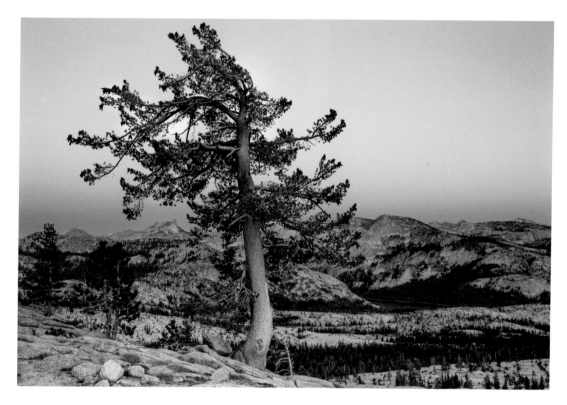

This place has been deemed sacred, protected, and valuable for its wild existence. Ideas of restraint and conservation have grown out of the Tuolumne landscape and spread throughout the world.

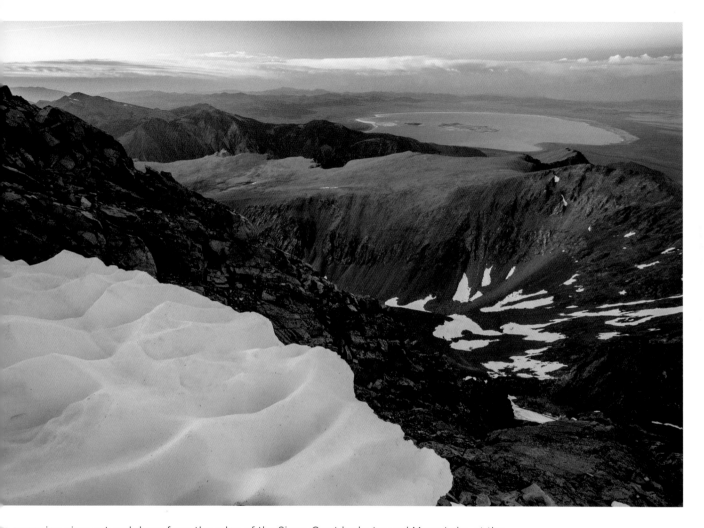

e sweeping view out and down from the edge of the Sierra Crest looks toward Mono Lake, at the
rder of Yosemite National Park. One departs reluctantly from the beauty and wildness of the Tuolumne
ɡh country, with revitalized senses soothed and tuned to the earth's rhythms. Leaving Tuolumne for
e first time, John Muir wrote in 1869: "I must turn toward the lowlands, praying and hoping Heaven will
ove me back again" (Muir, *My First Summer in the Sierra,* 1911).

YOSEMITE
CONSERVANCY.

Providing For Yosemite's Future

Through the support of donors, Yosemite Conservancy provides grants and support to Yosemite National Park to help preserve and protect Yosemite today and for future generations. The work funded by Yosemite Conservancy is visible throughout the park, from trail rehabilitation to wildlife protection and habitat restoration. The Conservancy is dedicated to enhancing the visitor experience and providing a deeper connection to the park through outdoor programs, volunteering and wilderness services. Thanks to dedicated supporters, the Conservancy has provided more than $81 million in grants to Yosemite National Park.

yosemiteconservancy.org